SISTERS OF THE GREAT LAKES

Art of American Indian Women

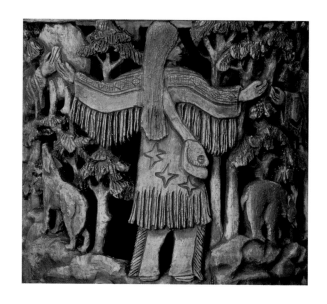

EDITED BY
MARSHA MACDOWELL AND JANICE REED

PHOTOGRAPHS BY DOUGLAS ELBINGER

MICHIGAN STATE UNIVERSITY MUSEUM
EAST LANSING, MICHIGAN

NOKOMIS LEARNING CENTER
OKEMOS, MICHIGAN

Printed in the United States of America
ISBN, softcover edition: 0-944311-08-3

On the cover:
 Shirley M. (Reichard) Brauker
 Sisters (detail), 1994
 Incised clay
 13 $\frac{1}{8}$ h.", 7 $\frac{7}{8}$" d.
 Sisters of the Great Lakes:
 The Nokomis Collection
 MSU Museum 7594.18; FAD 94.81.18

HONOR THE ARTIST

The artist is the voice of the country
For a long time, it seems
There was war
Everything was afraid
Many of our people were sleeping
The land, waters, the air, and animals were troubled.

The artist kept on working.

The prophecies are now coming true
Our young are the seventh generation
Making a difference as they prepare
The grounds for the next seven generations to come.

The artist is inspired and stronger than ever
The children have a place in the world again.

Honor the artist.

The basket maker dyes her splints of ash in many colors
They hang on the line to dry
They curl and dance with the wind
There is magic in the air
The children can dream.

The basket maker braids the sweetgrass
It's the hair of our Mother the Earth
There is a fragrance of comfort in the air
The children are strong.

She begins to weave her basket
A new song is heard
There is love in the air
The children feel affection from the Great Spirit.

The basket is round
It holds many sacred feelings
From the hands of the weaver
Beautiful children touch the basket
They receive a vision for the future.

Honor the artist.

Alanis Obomsawin
Montreal, Canada
March 1, 1995

CONTENTS

PREFACE

MARSHA MACDOWELL

A couple of years ago, an instructor at the Nokomis Learning Center was asked by a young elementary school visitor if there were any Indians left. The instructor, a Michigan State University student and member of the LacVieux Desert Tribe in Michigan's Upper Peninsula, was taken aback. "Of course there are!" she replied. "What do you think I am?" The children laughed, but it was a moment of educational awakening. The woman standing before them defied their idea of what an American Indian should look, talk, and act like, as well as where they live and work. The instructor, like many contemporary American Indians, confronts similar misunderstandings in her daily life.

Many American Indians speak of living in two worlds—the world of their community, which often maintains a traditional way of life, and the world outside that community. This duality of existence can cause conflicts among the religious belief systems, languages, customs, laws, and regulations of the tribal communities, other cultural communities, and the larger society. Throughout the history of North America, native peoples have mitigated and resolved conflicts, both large and small, in order to co-exist peacefully with other cultures while maintaining a sense of fundamental identity as a unique people. At the heart of their efforts is the issue of what it means to be Indian.

The exhibit "Sisters of the Great Lakes: Art of American Indian Women" was developed by the Michigan State University Museum and the Nokomis Learning Center in partnership with the artists involved. It speaks directly to the ways in which American Indians, specifically women living in the Great Lakes region, visually address the complexities of being Indian in a modern world. It is a wonderful cross-section of the ways that individuals express their identity as women, as artists, as American Indians, and as members of specific native communities. It counters stereotypical views of American Indian art, in general, and Great Lakes Indian art, in particular.

The group of women whose work is included in the exhibition came together as a result of their participation in the "Native American Women Artists: Transcending Boundaries for Future Generations" project, a year-long series of professional development workshops coordinated by the Nokomis Learning Center. The women initiated this exhibition and publication project as a means of celebrating their participation in the workshops and as a means of educating others about their art and heritage. They selected the items for the collection, which will be permanently housed at the Michigan State University Museum, and reviewed the text of this catalog. When the women gave the exhibit its name, it was with the clear desire that this collection would be seen as a whole. It is a testimony to the vitality and spirit with which

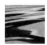

they individually—and now collectively—express their knowledge and traditions to others.

The exhibit illuminates the many and varied paths these women traveled as they acquired knowledge and technical skills, gathered materials, and experimented with forms and designs. Some of these paths are considered "traditional," a word that has different connotations inside and outside the Indian community. Oral, visual, and behavioral traditions are learned within the home or community, passed from one generation to the next, and have meaning for members of that group. The term "traditional arts" generally refers to work governed by a set of time-honored, community-based norms of practices, methods, materials, and values. The concepts of quality, excellence, and authenticity refer to the way in which the art is accepted by the community and contributes to the maintenance of customs and knowledge within that community.

The term "contemporary arts" refers to forms that are less bound by traditional community-based methods, purposes, materials, and forms. Generally, these forms are learned in a formal academic setting. Contemporary American Indian art is likely to express creative, individualistic ideas that may or may not have a direct, intentional function of contributing to the maintenance of specific customs.

However, the categories of "traditional" and "contemporary" are often blurred. In order to understand the importance of native art, it is more useful to examine the experiences of the individual artist, how they view their work, and how it is viewed within their respective communities.

Some of the artists included in this exhibit learned from their relatives and friends how to locate and prepare the natural materials they use, including porcupine quills, hide, fur, sweetgrass, birchbark, clay, and black ash. Mentored by their communities' master artists, the women fashioned these materials into art forms that have existed for years among Great Lakes Indians: porcupine quill embroidered birchbark boxes, dance regalia, dolls, pottery, and baskets. Other artists received some or all of their instruction in high school, college, or professional art schools. Some reported on the difficulties encountered in these learning environments, which are generally dominated by Western European concepts of art. For these artists, it is a challenging process to reconcile the worldviews and knowledge of their native communities with those presented—sometimes forced—in the classroom.

Yet, as this exhibition so clearly communicates, old values and knowledge have been maintained even as new techniques, materials, and forms are introduced. Artists continue to discover, interpret, and integrate important community-based knowledge in both traditional and contemporary art. Old symbols traditionally incorporated into three-dimensional weaving patterns may become rendered in acrylic paint on a two-dimensional canvas surface. A basketmaker uses commercial rather than natural dye to achieve a desired color. Beadwork traditionally done for elements of dance regalia may be used to adorn a baseball cap worn for everyday use.

The art produced by the women for this collection portrays only a small aspect of the rich expressive cultural traditions of

native peoples. Many of the women in this exhibition are talented in a variety of expressive forms, including dance, theater, poetry, and storytelling. The experiences of individual artists may include both familial and academic instruction, their work may include both traditional and contemporary materials and techniques, and their work may have meaning for several communities, native and non-native.

In examining this collection, it is important to know that each artist, regardless of training or the materials and techniques used, shares a common purpose: to express her ideas, emotions, and knowledge of what it is to be a woman, an artist, and an American Indian with a distinct tribal heritage centered around the Great Lakes region. Just as the young visitor to the Nokomis Learning Center was awakened to the reality of American Indians in today's society, so too will viewers of this exhibit be introduced to the contemporary presence of art that effectively and powerfully communicates the complex and multiple experiences of these artists.

Marsha MacDowell is curator of folk arts at the Michigan State University Museum and professor in the MSU Department of Art.

ACKNOWLEDGMENTS

The "Sisters of the Great Lakes" exhibition and catalog were made possible by the financial and in-kind support of the W. K. Kellogg Foundation, the Michigan State University Museum, the Nokomis Learning Center, the Michigan Council for Arts and Cultural Affairs, the MSU Native American Institute, and the Elizabeth Halsted Lifelong Education Endowment.

Many other organizations and individuals have given their time, knowledge, and skill to this project. Without the interest and support of the following people, "Sisters of the Great Lakes" would not have been possible: Cameron Wood, director, Nokomis Learning Center; Kurt Dewhurst, director, MSU Museum; Kayle Crampton, project coordinator, Nokomis Learning Center; Frances Vincent, exhibit designer, MSU Museum; Melanie Atkinson, LaNeysa Harris-Featherstone, and Lynne Swanson, collections coordinators, MSU Museum; Ruth D. Fitzgerald, publication coordinator, MSU Museum; Kristan Tetens, publication editor and project manager, University Relations; Cynthia Lounsbery, publication design manager, University Relations; and Douglas Elbinger, photographer.

We are also indebted to workshop presenters Vicki Copenhaver (Eiteljorg Museum), Ruth D. Fitzgerald (MSU Museum), Clara Sue Kidwell (National Museum of the American Indian), Trudy Nicks (Royal Ontario Museum), Alanis Obomsawin (Canadian Film Board), and Lori Lea Porier (Atlatl).

The development of the workshops and exhibit was guided by the thoughtful comments of advisory committee members Anna Crampton, Deborah Galvan, Valorie Johnson, and Mike Petoskey.

Special thanks are extended to the Nokomis Learning Center Board of Directors, the MSU Museum Board of Directors, and the MSU Museum Development Council.

The project received valuable assistance from Michigan State University Museum staff members Judy DeJaegher, Francie Freese, Rosanne Jekot, and Terry Hanson. Support was also provided by Nokomis Learning Center staff members Marclay Crampton, Jean Johnson, and Norma Rich.

The Lansing North American Indian Center, John Crampton, and Andy Chingman deserve special recognition for their time and effort. The families and friends of the artists also helped in many ways. To all of them, we say *Megwetch*.

—JANICE REED
—MARSHA MACDOWELL

SISTERS OF THE GREAT LAKES: SHARING AND CELEBRATING IDENTITY

VALORIE JOHNSON AND JANICE REED

"Sisters of the Great Lakes" is a celebration of native women: their endurance, their culture, their dreams.

It is a testament to their hope that others like them will one day be honored and respected for the strength and beauty they contribute to our world community. By bringing together the artistic visions of 20 native women, this exhibit demonstrates more profoundly than words ever can what it means to be native and female in contemporary society.

The idea for this project was developed at the Nokomis Learning Center, a non-profit organization in Okemos, Michigan, dedicated to preserving native customs and to educating the public about the indigenous peoples of the Great Lakes. The center is one of many locally and regionally operated cultural centers that strive to teach about the contributions of Indian tribes located in the surrounding geographical areas. When the Nokomis Learning Center opened its doors in 1990, enthusiastic crowds visited, eager to learn about the heritage of Native Americans. Center staff and volunteers soon discovered that the art and traditional crafts of the Great Lakes tribes are tremendous tools for teaching others about unfamiliar cultures. Visual representations of the myths, legends, symbols, and designs of local tribes and the natural materials used to create them are now central to the hands-on teaching method of the center.

Consequently, the curriculum that the center developed to accomplish its mission is based on the use of objects created by the artists and artisans of the Great Lakes. Teaching adults and children about the beauty, traditions, and fine craftsmanship of the work of Great Lakes natives has two benefits: an increased awareness and appreciation of Indian art and an expanded market for the unique and beautiful objects made in this region.

In the spring of 1993, several women met at the Nokomis Learning Center to discuss how they could strengthen the ties between teaching and art. They were also eager to develop strategies that would address the social and economic needs of native women artists in the Great Lakes region.

In terms of social and economic conditions, native women have the "distinction" of being the poorest of the poor: they have extremely high dropout and unemployment rates, a high frequency of suicide, and higher-than-average divorce rates. As heads of households, a majority are under the poverty level. They earn the lowest wages and are often in poor health. As if that were not enough, they constantly encounter prejudice based in the stereotypes of Hollywood, including the passive, silent "Bambi" types found in early western movies. For decades, native women across the country have attempted to improve their living conditions and to

capitalize on their inherent strengths. One way that native women express their desire for better lives is through art. Its beauty remains largely undiscovered in many regions of the country and is particularly unknown in the Great Lakes area.

The group of women who met at Nokomis in the spring of 1993 formulated a plan to address some of these issues, heeding the words of Black Elk: "A vision without a plan is but a dream. A plan without a vision is pure drudgery. But together, a vision with a plan can change the world." Together, they developed a plan that they hoped would change, if not the entire world, at least the center's corner of it.

Their plan included the development of a two-year project funded by the Kellogg Foundation called "Native American Women Artists: Transcending Boundaries for Future Generations." The first goal of the project was to increase the public's awareness and appreciation of the quality, beauty, and unique characteristics of Great Lakes Indian art. When people think about Native American art, it is often the art of the Southwest tribes that comes to mind. The peoples of the Southwest have been very effective in educating the public about the designs, colors, textures, and culture-specific arts of their region. The aim of the Nokomis project was to achieve the same result for the beautiful work done throughout the Great Lakes region and to teach the public how to recognize regional differences in native art.

The second, and perhaps most important, goal of the project was to provide Great Lakes Indian women artists with a set of professional skills through workshops in marketing, networking, small business development, and mentoring. Twenty Native American women, nominated by a panel of their peers, were selected to participate in three four-day workshops held between July 1993 and June 1994. The artists represented a range of artistic media, age, tribal affiliation, and experience. They came from Michigan, Wisconsin, Illinois, New York, and Ontario. All but two are members of Great Lakes area tribes; the two who are not consider themselves Great Lakes because they have lived most of their lives in this area and are committed to the region.

By providing opportunities to bring the women together, the project enabled them to see and experience their collective strengths as healers, herbalists, clan mothers, educators, political leaders, and artists. The synergy produced by the gatherings became apparent very quickly, as the women learned from each other and combined to produce a group effect more powerful than the sum of their individual, isolated efforts. During the second year of the project, its participants became known as the "Sisters of the Great Lakes," or "Sisters," and it is their work during this time that resulted in the creation of this exhibit.

Each workshop session included time for sharing experiences and information. It was sometimes difficult to keep the sessions on track because there was much the women wanted to discuss and they were eager to show each other their work. Many evenings were spent with one artist demonstrating her art and techniques to the others. Sally Thielen spent several evenings "plastering" various fellow artists who volunteered to act as models while she demonstrated her mask-making

technique. One after another, they climbed up on a table and let Thielen smooth plaster over their faces while they breathed through straws. The mask in this exhibit is an image of one of the women in the "Sisters" group.

For many of the participants, their art is a spiritual link with their traditions and is sometimes inspired by dreams and visions. Shirley Brauker often incorporates dream imagery in her incised pottery. Before her participation in the "Sisters" group, however, she had never depicted women in her work. Encouraged by the fellowship of her sister-artists, she created her first piece that includes female figures for this exhibition.

Dreams and visions are what keep sculptor Diane Quillen working. Quillen was particularly impressed by the other women in the group. However, because of transportation difficulties, she almost did not participate in the project. Kayle Crampton, another participant, arranged car pools and rides so that it was possible for everyone to travel to the workshops. During the workshop weekends, Anna Crampton (Kayle's mother and a participant herself) often volunteered to drive those artists without cars around town during their stay. Arranging rides and car pools turned out to be an important and significant key to the success of the project. Workshop organizers also found that they needed to be flexible when making arrangements for housing over the workshop weekends. Many of the participants were single parents who needed to bring their children with them. The women sometimes needed to leave the group for an evening to be with their children or with other relatives in the mid-Michigan area.

Few of the artists have studios or workshops in which they work; most work in their homes and create their art in the kitchen or living room. Sometimes the artists work during a break at pow wows. Lorraine Shananaquet is one of these. Her traditional beadwork is only one facet of her cultural expression. A busy mother of two young children, she makes time whenever and wherever possible to work on her art and to create the traditional regalia worn at pow wows by herself and members of her family. Linda (Topash) Yazel is another artist who never stops working. She and many of the other artists worked at their art while listening and participating in the project workshops. Whenever there was a break, the others would flock to them to watch and ask questions. They talked often of how much they would love to have "master artist" sessions that would be devoted to one artist who would create and discuss her work. All 20 women were eager to learn from one another; each was a natural mentor.

One unfortunate characteristic of the established art world is its tendency to discount native art if it is not "traditional" in appearance. When a native artist's themes or media do not fit the accepted idea of what native art should look like, that artist's work is often criticized for not being "Indian" enough. No culture is static, however, and cultural evolution means adapting without giving up traditional ways. Seneca-Cayuga artist Tom Huff notes that "Indian art brings back the past, strengthens the present, and gives hope for the future. It is the maintainer of life for our people." Contemporary media and technology have inspired some of the artists in the "Sisters" group to discover

new ways to express their traditions and cultural identities. Several participants use the materials of the dominant culture while continuing to ground their art in native imagery or forms.

Jolene Rickard is a good example. Her photography uses modern technology and equipment to express the meanings of the time-honored stories of native peoples. A perfectionist with a clear vision who advocates self-definition among native artists, Rickard continues to break new ground as an activist and creator. She taught other group members the best way to photograph their work for use in promotional materials. Tammy Tarbell-Boehning uses clay, beads, horsehair, deerskin, and fur to create her unique blends of old and new artforms. The other members of the group were absolutely awed by the beauty of her work, which most had never seen because she lives in New York. Those who had seen it were eager to meet her. It was Tarbell-Boehning who suggested "Sisters of the Great Lakes" as a title for the exhibition.

Raw silk is frequently the medium chosen by Carol Babcock-Elder. Her warm personality helped to create lasting friendships among the women. Dolores Laban's choice of medium—stained glass—is an unusual one among native artists. It was not easy for Laban to attend the workshops because of her work schedule, but she, too, felt enriched by the friendship of the others in the group and by the networking opportunities available. Strengthened by these new relationships, several of the women embarked on new voyages of self-discovery. Laban and others participated in some of the same art shows

during the project year, seeking each other out whenever possible.

Debra Pine uses silver for her jewelry creations, a material usually associated with the Southwest tribes. However, Pine's themes clearly derive from the legends and symbols of the Great Lakes Woodland tribes. Pine was particularly interested in the marketing and business information provided in the workshops and she spoke often of forming her own business. She is already quite well known, both for her own art and for her advocacy of other Great Lakes Indian artists.

Sometimes, through research or the gathering of materials, the women learn more about their cultural heritage and pass that knowledge on to others. For each of the "Sisters" participants, it is a journey of self-discovery that will never end. "Sisters" artist Sandy Dyer, for example, is apprenticed to Frank Ettawageshik, a well-known Odawa potter. She is learning how to create traditional Woodland earth-fired clay pots using centuries-old designs and techniques. Dyer was very modest in her acceptance of the invitation to join this project. She believed that since she was still apprenticed, she didn't have as much to offer as many others in the group. However, she too became inspired by the "Sisters" and found that she had much in common with them.

One by one, as the women became acquainted, the bonds between them grew stronger. Artist and storyteller Lois Beardslee, long an outspoken advocate of Great Lakes Indian art and artists, felt the kinship of her sister artists strongly. Beardslee had much to share with the others. In turn, she was profoundly affected by the group and in particular by the

films of Alanis Obomsawin. A member of the Canadian Film Board, Obomsawin conducted the final workshop. Watching *Incident at Restigouche, Christmas at Moose Factory*, and *Richard Cardinal* and discussing these films with Obomsawin was a powerful experience for the group. They felt newly empowered to speak about native women, their own heritage, and their traditions as reflected in their art.

Each of the "Sisters" is a uniquely special person, but if one could be singled out as the glue that kept the project together, it would be Anna Crampton. She was one of the few artists in the project who knew everyone else in the group before it was formed. She has been a dedicated board member of the Nokomis Learning Center for several years and a staunch supporter of the center's educational programs. In fact, Crampton introduced the center's staff to many regional native artists and urged them to collect new works for teaching exhibits and sale in the center's gift shop. The Crampton home is frequently host to visiting Indian friends and acquaintances. Seeing the "Sisters" group come together was a joy for her; she loved interacting with them and watching them interact with each other. During the workshop weekends, she spent a good part of each day and night in the hospitality room of the hotel where the women stayed, offering whatever assistance she could. This comfortable room, open all evening, was a place where the women could gather with refreshments and get to know each other. Many new friendships were formed and old friendships strengthened in the hospitality room.

The networking benefits of the project were apparent before the end of the first year. Casey and Becky Munz successfully applied for a grant to bring Anna Crampton to Wisconsin to demonstrate black-ash basketmaking. Artists were interested in each other's experiences and quick to incorporate tips into their own marketing practices. Sometimes the information concerned pow wows, art shows, or grants; sometimes it concerned apprentice programs and how they might participate.

Kayle Crampton, a graphic artist, identified the need for mentoring among native women artists. During the workshops, she had the difficult task of coordinating the activities of the group while trying to interact as a participant herself. While arranging for photography of the individuals in the group, Crampton (who is also a professional photographer) learned more about her own profession.

Yvonne Walker-Keshick is one of the premier porcupine quill artists in the country. The workshops and the deepening friendships with the other women in the group had a profound impact on her. "I realized that as women, we too are the warriors," she says. Before her participation in the project, her subjects had been traditional themes and legends. Now she has turned to depicting women's roles and life cycles.

Casey Munz found that the fellowship of her sister artists and elders inspired her to reach beyond the limited teachings of her public high school classes; she now seeks a fuller knowledge and expression of her cultural beliefs. Her mother, Becky Munz, knows too well the obstacles to finding accurate information about native culture. She became a dollmaker partly out of her frustration at not being able to find native dolls for her children. Becky

and Casey were one of several mother-daughter pairs in the "Sisters" project. They accepted the invitation to participate on the condition that they would do so as individual artists. In spite of her young age, Casey wanted her participation to be an independent learning experience. Throughout the workshops, she added a fresh perspective and voice.

The group's other dollmaker, Sharon Skolnick, was one of the few participants familiar with the business concepts of marketing and public relations. However, she had not established a network of many other Great Lakes women artists. Skolnick had to travel by train to each workshop, but did so enthusiastically. As the owner of an American Indian art gallery in Chicago's Andersonville neighborhood, Skolnick generously shared her business experience and knowledge with the other participants.

Lavina Day was Nokomis (Ojibwa for "grandmother") to the group. The experience of coming together with other native women artists was a new one for this octogenarian. At the end of the first workshop, Day proclaimed "I am so proud of what my people can do." Her baskets are eagerly sought after by other native artists and collectors. Day has lived all her life on Walpole Island in Ontario, Canada, as has "Sisters" quilt artist Leda Johnson. The two women traveled to each workshop together. Johnson made it known to the group right away that she was not a public speaker, but was happy to be there to listen.

The joy, personal growth, and professional development experienced by these 20 native women artists during the "Sisters of the Great Lakes" project is evidenced by their work in this collection, which represents some of the finest work of their careers. Each of the women has individual strengths. Some have many. Some are articulate, some have humor, some have quiet strength, some have great knowledge. All have dignity, beauty, creativity, and the desire to express the traditions and stories of their people. The sum of their work is their essence and their power.

Valorie Johnson (Seneca-Cayuga) is a program officer at the W. K. Kellogg Foundation and a doctoral candidate in education at Michigan State University. Janice Reed is former director of the Nokomis Learning Center and project director for "Native American Women Artists: Transcending Boundaries for Future Generations" and the "Sisters of the Great Lakes" exhibit.

OUT OF THE PAST, INTO THE PRESENT

DEBORAH GALVAN

"Sisters of the Great Lakes" truly brings Indians out of the past and into the present. The women artists included in this exhibition and catalog represent a variety of tribal groups from Michigan, New York, Illinois, Wisconsin, and Canada. For all who see this exhibit, Indians will no longer be only a part of our nation's past; they will also be seen as a vibrant people contributing to our present, with a very bright future ahead.

As a member of the planning committee for this exhibit, I was pleased to be part of such an exciting and energizing project. The rich diversity that exists within this group, the value of the project to the artists, and the excellent teaching tool that was created all attest to the project's significance.

When first hearing of this exhibit, some may wonder: What tribes have inhabited the Great Lakes region? Do they continue to live there today? What are their contributions to the art world?

These questions should not be surprising. Many Americans, saturated with media representations of Native American culture, believe that most Indians live west of the Mississippi River. Nearly all depictions of Indians represent only the culture and customs of the larger tribes of the Plains and Southwest.

I would like to share a personal story that goes back 36 years. At that time I was attending school on the Northern Cheyenne Indian Reservation in Montana. In a class on Montana history, I learned that Comanche (a horse belonging to the United States cavalry) was the lone survivor of the Battle of the Little Big Horn. How strange it seemed to me that my grandmother could tell me stories of many survivors. Of course, those survivors were Cheyenne and Sioux and not in our history books. It was important to me, even then, that we be allowed to tell the stories of our own experiences. This exhibit does just that.

I mention this because, even as the curricula in American and Canadian schools change, many tribes continue to be excluded from discussion. All Indians are thought to be members of the Plains or Southwest tribes. Many children continue to learn about Indians in conjunction with an American history class timed to coincide with Columbus Day or Thanksgiving Day. Near the latter holiday, the children "dress up" like "Indians" (at least the Hollywood depiction of the Plains Indian) and share a meal with "Pilgrims." In many cases, this is the full extent of formal education about Indians, and children come away with the impression that Indians are part of the past, not the present.

Although recent portrayals of American Indians in the media are an improvement over the past, the Indian continues to be viewed homogeneously, without regard for

tribal differences. Seldom are Indians portrayed as an integral part of today's society.

Before turning to the exquisite "Sisters of the Great Lakes" collection, we should take a few moments to consider some important facts about Indians in contemporary society, since it is the environment in which native artists work. In 1990, Harold L. Hodgkinson, a well-known demographer, prepared a report called *The Demographics of American Indians: One Percent of the People, Fifty Percent of the Diversity.* This report includes the following observations.

- Americans speak more than 200 non-Indian languages. There are 1.7 million American Indians in the United States (less than 1 percent of the total population), who speak an additional 200 languages.
- For every endangered species of plant or animal, there are about five endangered American Indian cultures.
- Although there are approximately 500 different tribes, ten tribes account for more than half of the American Indian population.
- Only 25 percent of Indians currently live on reservations.

These data help demonstrate the diversity among American Indian tribal groups. Perhaps it helps us understand why movies and the art world have concentrated on Indians of the Plains and Southwest: because more is known about these large groups, they tend to draw attention. A problem arises, however, when all Indians are stereotyped based on this information. An environment has developed in which art is recognized as "Indian art" only if it appears to represent the work of selected Plains and Southwest artists.

The planning committee and the women artists involved in the "Sisters of the Great Lakes" project shared a vision: to provide an accurate portrayal of contemporary American Indian women living in the Great Lakes region. We have always spoken of our lives and our dreams through our art. It tells others who we are, what we have experienced, and our dreams for the future. It also has a lasting value that prevents it from being lost in our oral tradition.

The enthusiasm of the women for the project, their respect for each other, and their earnest desire to reach other audiences led to the development of this traveling exhibition. Throughout the project, the women searched for ways to maintain contact with each other while including and assisting new artists. These women are committed to seeing that "Indian art" survives and often speak of passing their art on to the next seven generations. It was the consensus of the "Sisters" group, as well as the opinion of the planning committee, that the "Indian" in "Indian art" refers to the artist and not the subject of the art.

The effect of the project on the artists was immediate and clear. For some, it was the first time they had used the word "art" instead of "craft" to describe their activities. They served as mentors, they learned from each other, they enhanced their business acumen. All were eager to make their mark on the world and ready to develop their finest pieces for this exhibit.

In their work you will see their ties to the land, to the water, to the culture, and to the other women of the group. Wherever this exhibit travels, the spirit of these women will be there.

The pieces included in the exhibit truly transcend boundaries. Some are traditional, some are contemporary; some use media not available to past generations, some use traditional media and methods to develop a new technique, a new design, or a new product. Some have even bridged the gender gap by participating in art forms once reserved for male artists.

Thanks to these artists, we have an incredible tool to teach others about the Indians of today. What better way to learn about the lives of members of the Great Lakes tribes than through their own art? The works compiled in this exhibit allow us to draw comparisons to the past while viewing the present and discussing the future. The collection does not resemble museum exhibits of 100 or 50 years ago, nor should it. Societies are forever changing—is it not the same for the Indian community?

Some of the artists included here work diligently to preserve what their grandmothers taught them of the past while others create a completely new view of the world. The important point to remember is that both approaches constitute "Indian art."

As you look at these works, you will see and feel the strength of the women and their ties to the Great Lakes region. We hope that you will become interested enough to want to learn more about the Indians of this area. There are several themes that are common throughout groups of the pieces included here. A few of these are detailed below and will help familiarize you with some of the customs and cultures of the Indians of this region.

• The Turtle

An image of a turtle can be found in many of the items in the exhibition. The turtle plays an integral part in the creation stories of Great Lakes tribes. In these stories, various animals brought dirt up from the bottom of the sea and placed it on the turtle's back. There it grew, developing into a substantial land mass. The water and air beings existed at that time and are credited with providing an environment in which humans could exist. Mackinac Island, located in Lake Huron between the upper and lower peninsulas of Michigan, is frequently referred to as the Great Turtle.

• The Importance of Women

Nearly half of the items in the exhibition include women or the female experience as subjects or themes. In some of the pieces, women are a central and very visible focus of attention. This feature of the collection speaks to more than the mere presence of women in a gender-specific display. Rather, it stresses the importance of women in Indian life. The earth itself is Mother Earth, the supplier of all life forms. From Mother Earth, all life emerges and is ultimately returned.

• Respect for the Sacred Circle

Respect for the Sacred Circle is evident throughout the exhibit. It takes many shapes yet remains fluid and continually joined. It is evident in the Three Sisters of corn, squash, and beans that grow from Mother Earth. It is evident in pieces that include the beings of the land, air, and water,

whose existence is not based on a hierarchical structure. They must all respect each other in order to maintain the proper balance within nature. If you look closely, you will even see the Woodland colors that form the Sacred Circle: yellow (east, the morning sun, birth, beginnings, spring); red (south, the vibrancy of youth, summer); black (west, the setting sun, maturation, fall); and white (north, the wisdom of age, winter).

• New Art Forms

Art forms usually associated with Indian men—but here used by Indian women—include masks, stone sculpture, and silver jewelry. New forms not traditionally associated with Indians can be seen in the collection's contemporary drawings and paintings, stained glass, and photographic pieces.

• Traditional Materials

The natural resources of the Great Lakes region are important sources of materials traditionally used by native artists. In this exhibit, look for these materials gathered from the earth and animals: birchbark, clay, feathers, bone, leather, hide, porcupine quills, turtle shells, and sweetgrass. The use of these materials gives Great Lakes American Indian art a distinctive look.

• Woodland Indian designs

In addition to the turtle and the sacred circle, the Sisters artists use symbols and designs with particular meaning to Woodland Indians. Many of these images depict birds, animals, plants, and environmental features found in the region or those that figure prominently in traditional stories. Artists also use designs representing their clan symbol or Indian name. In quillwork, ribbonwork, beadwork, quilting, and basketweaving, artists often use figurative or geometric designs passed down in their families. Look for strawberries, loons, turtles, pine trees, water, the Underwater Panther, the Thunderbird, and floral designs.

• Traditional Forms and Techniques

Among Great Lakes regional native peoples, arts have long been an important way of maintaining cultural traditions and strengthening cultural identity. Woodcarving, black ash splint basketmaking, sweetgrass braiding, earth-fired pottery making, fingerweaving, quiltmaking, the various skills associated with creating regalia, and porcupine quillwork embroidery on birchbark are among the processes closely associated with Great Lakes Indian arts. In this exhibit you will see several examples of these forms. In addition, the exhibit will introduce you to the relatively new tradition of floral beadwork. Before 1800, Indian beadwork consisted primarily of geometric designs. Since that time, however, floral designs have become popular with beadwork artists. The designs that have evolved are highly decorative and intricate.

The project that ultimately resulted in this traveling collection far surpassed the wildest expectations of the planning committee members. Perhaps we underestimated the power of these exceptional women artists. Indeed, this project has created a new family. The "Sisters" are family through their art, their heritage, and especially through their willingness to ensure that future generations will know and understand the lives of those who walked before them. Their work has strength. Their work has beauty. And above all, their work demonstrates the perseverance of American Indians. These are the Sisters of the Great Lakes.

Deborah Galvan (Northern Cheyenne), is president of the board of directors of the Nokomis Learning Center in Okemos, Michigan. She is the assistant director of the Office of Supportive Services at Michigan State University.

THE ARTISTS AND THEIR WORKS

TEXT BY MARSHA MACDOWELL AND JANICE REED
PHOTOGRAPHS BY DOUGLAS ELBINGER

The biographical information presented here has been provided by the women themselves. All reference materials, including transcripts of interviews with selected artists, are housed in the Michigan Traditional Arts Research Collection at the Michigan State University Museum. For information, please call the museum at 517/355-2370.

The reader will notice inconsistencies in the spelling of tribal names. The MSU Museum and the Nokomis Learning Center have honored individual artist preferences for tribal attribution and spelling. There are also inconsistencies in the listing of native names and translations. These, too, are recorded here as the women use them.

CAROL BABCOCK-ELDER
Earthpower, 1994
Acrylic on raw silk
36¼"h. x 36¼"w.
Sisters of the Great Lakes: The Nokomis Collection
MSU Museum 7594.14; FAD 94.81.14

CAROL BABCOCK-ELDER

Miskwanakwad-quay (Red Cloud Woman)
Hannahville Potawatomi
Marquette, Michigan

Born on the Hannahville Potawatomi Reservation in the Upper Peninsula of Michigan, Carol Babcock-Elder cannot remember a time when she didn't paint or draw. She was exposed to a variety of traditional art forms early in her life and eventually studied art at the Toledo Museum of Art. She holds a bachelor of fine arts degree from Northern

Michigan University. A former curator of the Marquette County Historical Museum, Babcock-Elder now works full-time at her painting. She is a member and curator of the Oasis Fine Arts Gallery in Marquette, where she lives in a log cabin home on ten acres of woodlands. She remains firmly connected to and active within her Hannahville home reservation community.

Although Babcock-Elder acknowledges that she would probably be considered an "urban Indian," she states firmly that her spiritual beliefs and practices have always been traditional. Her paintings, usually executed on large canvases and sometimes on raw silk, incorporate stylized images drawn from her heritage. "My paintings are a composite impression of places I have imagined," she states. "They are expressions of feelings about nature's moods without being literal. I paint images in an abstract format, drawing from the natural and Native American world."

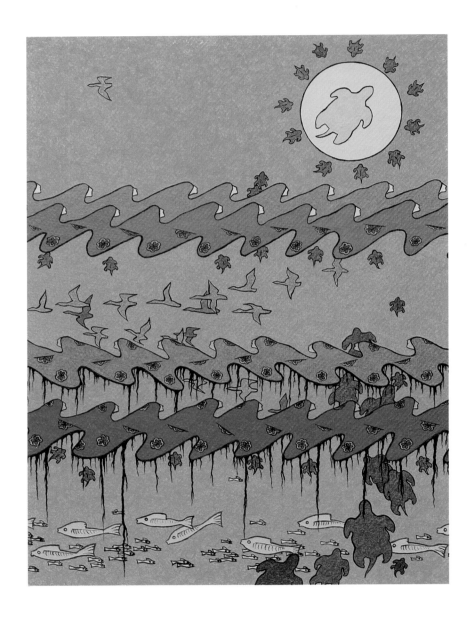

LOIS BEARDSLEE
Keepers of the Water, 1994
Oil pastel on paper
14¾"h. x 11"w.
Sisters of the Great Lakes: The Nokomis Collection
MSU Museum 7594.16; FAD 94.81.16

■

LOIS BEARDSLEE

Ojibwa/Lacondon
Maple City, Michigan

Lois Beardslee is both Ojibwa and Lacondon (a South American tribe). Her art reflects a lifetime spent in northern Michigan, interaction with other tribal members, and the for-mal study of Native American art history. As a teenager, she was pro-foundly influenced by the work of Yvonne Walker-Keshick, with whom she worked at the Traverse City Indian Center. She completed a bachelor's degree in art history at Oberlin College in 1976 and earned a master's degree in art history from the University of New Mexico in 1984. Her work incorporates traditional techniques, materials, and images drawn from her knowledge and experience. She gathers pigments for her paints from the earth in northern Michigan and finds design inspiration in ancient pictographs and Woodland Indian legends.

Beardslee's work reflects her desire to use art to fight the pervasive stereotyping of the Native American community. She has long been active in organizations concerned with issues relating to native artists. In the 1970s, she was one of the original members of the "Grey Canyon Artists," a Native American artists' cooperative in Albu-querque, New Mexico. She participates in the Great Lakes Indian Artists Association. Her involvement in the Native American Wo-men Artists" project has prompted her to explore the themes of Native American culture, women, and water in her work.

In addition to painting, the multi-talented Beardslee also specializes in bead-work and is a superb storyteller. Her presentations to audiences of all ages, tribal and nontribal, are filled with tales of Nanabush and other Woodland Indian figures, as well as personal reminiscences of her childhood. Her stories have recently been collected and recorded on audio cassettes as *Leelanau Earth Stories*.

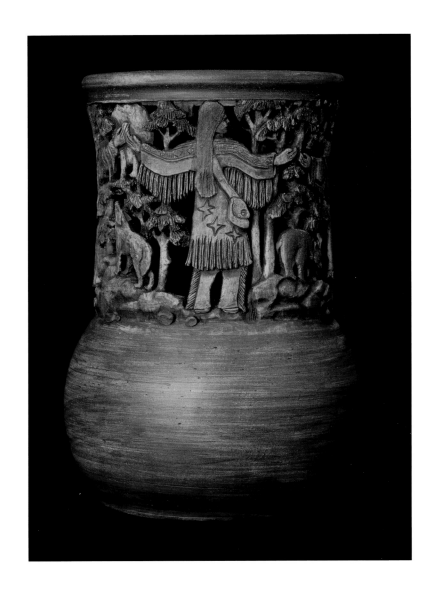

SHIRLEY M. (REICHARD) BRAUKER
Sisters, 1994
Incised clay
13⅛"h., 7⅞"d.
Sisters of the Great Lakes: The Nokomis Collection
MSU Museum 7594.18; FAD 94.81.18

■

SHIRLEY M. (REICHARD) BRAUKER

Go-gee-zis muckwa (Moon Bear)
Odawa
Coldwater, Michigan

Born in Angola, Indiana, Shirley Brauker was raised in the blended cultural traditions of her Odawa mother and her German father. She received a master of arts degree from Central Michigan University in 1983 and was recently honored as one of that university's "One Hundred Most Memorable Alumni of the Last Hundred Years." In 1991, Brauker continued her formal art education at the Institute of American Indian Arts in Santa Fe, New Mexico. Her work has been included in local and national juried and invitational shows, where it regularly receives awards. In March 1995 she traveled to the Heard Museum in Phoenix, Arizona, where she competed with more than 200 artists in a juried show.

Brauker lives in Coldwater next door to her parents in a home she built with the assistance of friends. Here she maintains a studio and business—Moon Bear Pot-

tery—and teaches children about her art and heritage in workshops and public school programs. Her son Austin is a talented artist in his own right. Further extending the artistic talents of the family, Brauker's young granddaughter Aryl Rae has already begun to paint and work in clay.

Over the years, Brauker has developed a style of pottery that draws heavily on her Native American heritage. Her pots are wheel thrown and hand built with intricate symbolic designs carved into the surface. Because she expects viewers of her work to acquire a new awareness and appreciation for Indian culture, she is especially attentive to the authenticity of the designs and stories she uses: it is not unusual for her to spend many hours researching the significance of a single artistic motif. In order to fully convey the meaning of each piece to its viewers, Brauker often writes stories to explain and accompany her pottery.

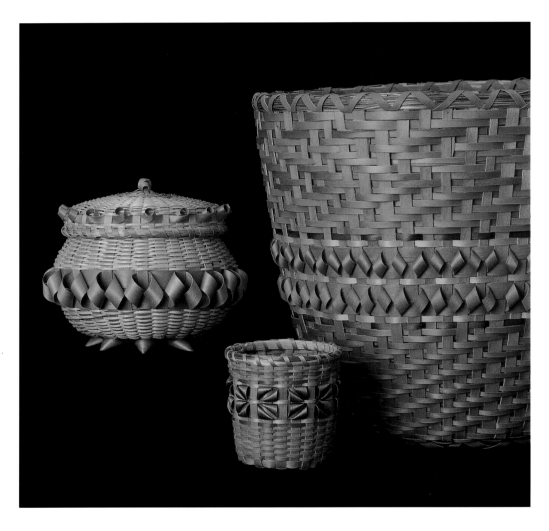

ANNA CRAMPTON
Sewing basket, waste basket, pencil holder, 1994
Woven black ash and sweetgrass
Sewing basket with lid: 6½"h., 6½"d.
Waste basket: 13"h., 14½"d.
Pencil holder: 4"h., 3¾"d.
Sisters of the Great Lakes: The Nokomis Collection
MSU Museum 7594.9; FAD 94.81.9
MSU Museum 7594.10; FAD 94.81.10
MSU Museum 7594.8; FAD 94.81.8

■

ANNA CRAMPTON

Pet-A-Gish-Go-Qua (Cloud Lady)
Saginaw Chippewa/Grand River Ottawa
Haslett, Michigan

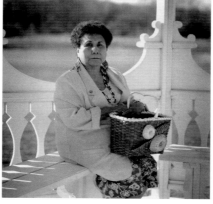

Third-generation black ash basketmaker Anna Crampton grew up on a small farm in Rosebush, Michigan. The daughter of Michael and Eliza Neyome, she has vivid childhood memories of playing in the large baskets her mother made, then listening intently as she was told how the baskets were constructed. To this day, her mother's sewing basket design remains a signature style for Crampton, who has passed on the tradition to three of her six living children.

Crampton is an active and much sought-after teacher of basketmaking who has instructed dozens of native and non-native beginners. Her husband John assists her with the arduous preparation of the black ash splints required in the basketmaking process. They travel frequently and enjoy meeting other artists at pow wows. They generously share their skills in workshops involving schools, art groups, and tribal gatherings.

Basketmaking is a traditional art form that was once practiced by hundreds of Native Americans in the Great Lakes region. Baskets were made for a wide variety of uses in the home, fields, and woods. They were also sold to supplement family incomes. Basketmaking is an endangered practice today because it is such a painstaking craft; few artists remain who are knowledgeable and skilled in all of the necessary steps. It can take an entire day to locate a suitable black ash tree. The trunk must be straight, free of knots, of a certain age, and harvested at just the right time of year. Once the tree is cut down, it is hauled out of the woods and cut into sections. The sections are then pounded to separate the rings of growth into strips (splints), which are used to weave the baskets.

In 1991, Crampton was honored as a master artist in the Michigan Traditional Arts Apprenticeship Program coordinated by the Michigan State University Museum and sponsored by the National Endowment for the Arts and the Michigan Council for Arts and Cultural Affairs. Her work is included in many public and private collections.

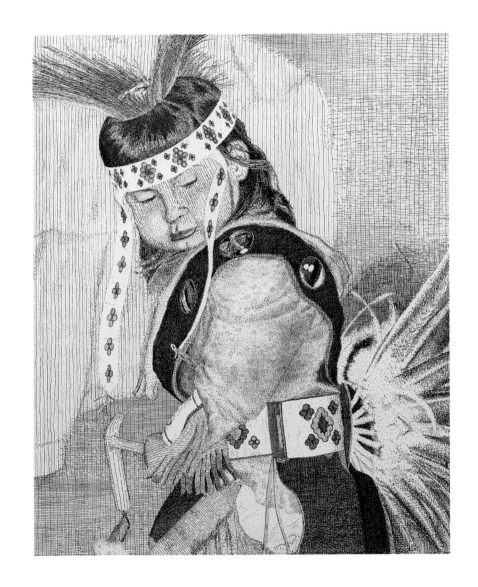

KAYLE CRAMPTON
Nin Giwitashim (I Dance Around), 1994
Pen-and-ink drawing on rag paper
24¼"h. x 19⅛"w.
Sisters of the Great Lakes: The Nokomis Collection
MSU Museum 7594.22; FAD 94.81.22

■

KAYLE CRAMPTON

Saginaw Chippewa/Grand River Ottawa
Lansing, Michigan

Kayle Crampton's family has always been deeply involved in its Native American traditions. Daily exposure to the craftsmanship of her mother, master basket-maker Anna Crampton, was a key factor in her decision to pursue art as a career. Crampton enrolled in art classes in high school, studied design at Lansing Community College, and later earned a bachelor of fine arts degree at Kendall College of Art and Design. Though she enjoys pottery, jewelry-making, and photography, she prefers to work in graphic arts. Crampton's work is inspired by both her Native American heritage and the world around her. She uses contemporary designs to link her family traditions with modern experience.

Kayle Crampton is a strong supporter of native artists, whatever their subjects, themes, or media. She is one of several women in the "Sisters" project who has experienced discrimination by the dominant culture when her work did not contain obvious references to historical and traditional Native American culture. "When I want to please myself," she notes, "I prefer to create contemporary designs and patterns. When I want to show my work at galleries or in exhibits, I often return to traditional themes."

Crampton is active in the Great Lakes Indian Artists Association, a multi-tribe organization that provides support to native artists. She recently illustrated the book *Walk in Peace,* written by Native American elder Simon Otto. She served as project coordinator for the "Native American Women Artists" project and is office coordinator for the Ziibiwing Cultural Society of the Saginaw Chippewa Tribe in Mt. Pleasant, Michigan.

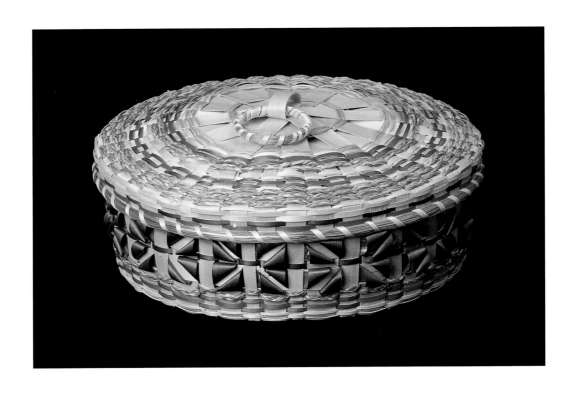

LAVINA DAY
Sewing basket with lid, 1994
Woven black ash and braided sweetgrass
4"h., 11½"d.
Sisters of the Great Lakes: The Nokomis Collection
MSU Museum 7594.11; FAD 94.81.11

■

LAVINA DAY

Wanaasin (Flys Well Nicely)
Chippewa
Wallaceburg, Ontario

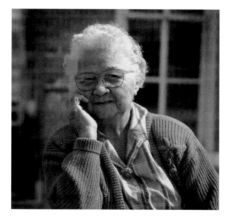

Lavina Day has lived on the Walpole Island Reservation in Ontario, Canada, since her birth in 1912. She learned basketmaking from her mother, grandmother, and aunt. They taught her how to locate and prepare natural materials like black ash and sweetgrass, and passed on traditional weaving and braiding patterns, forms, and techniques. Day is recognized as a master basketmaker within her community and has managed to teach the necessary skills to some of her seven sons. Son Maury makes sweetgrass baskets with her; together they travel to pow wows to sell their work.

Like other traditional basketmakers in the Great Lakes region, Day has developed a style that reflects regional patterns and construction techniques. Her distinctive baskets, which incorporate sweetgrass and the use of specific colors and color combinations (especially teal and deep pink), make her work easily recognizable. The rich colors of her baskets are achieved by the use of commercial dyes that are no longer available.

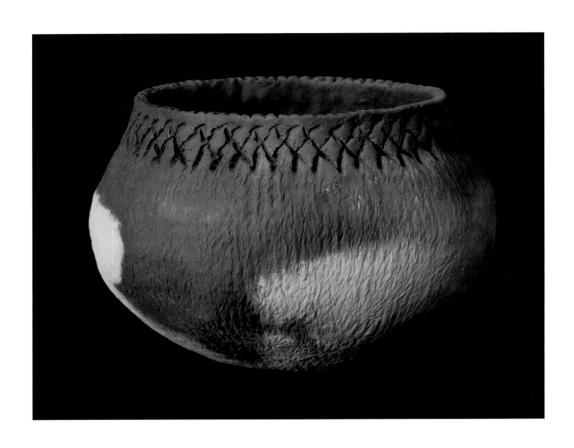

SANDY DYER
Woodlands open pot, 1994
Earth-fired clay
4"h., 4½"d.
Sisters of the Great Lakes: The Nokomis Collection
MSU Museum 7594.17; FAD 94.81.17

∎

SANDY DYER

Makoon-se-kwe (Little Bear Woman)
Odawa/Choctaw
Interlochen, Michigan

Sandy Dyer, a member of the Little Traverse Bay Band of Odawa, comes from a community rich in traditional heritage. Within her own family are some of the region's best-known porcupine quillworkers and story-tellers. Dyer is also a skilled traditional dancer who participates regular-ly in area pow wows.

Her interests in the traditional ways of her people and in working with clay led to an informal apprenticeship with well-known master Woodland Indian potter Frank Ettawageshik in 1986. Dyer continued her work with Ettawageshik through a 1993 Michigan Traditional Arts Apprenticeship coordinated by the Michigan State University Museum and sponsored by the National Endowment for the Arts and the Michigan Council for Arts and Cultural Affairs. Under his guidance, Dyer learned how to gather the natural resources need-ed to create the earth-fired clay pots that have been used for centuries by Woodland tribes. "It's like going back in time," says Dyer of the painstaking process of digging clay, forming and decorating pots, and firing them in an earthen pit.

Dyer is not yet a full-time potter; for now it is enough to make pots for her own satisfaction and to give to friends and family. By taking her young son with her into the Michigan woods to search for the right kind of clay for her pots, Dyer feels she is sharing with him a spiritual connection to the earth and her tradi-tions. She also enjoys teaching others about Woodland pottery making, includ-ing youth in summer camps run by the Grand Traverse Band of Ottawa and Chippewa Indians.

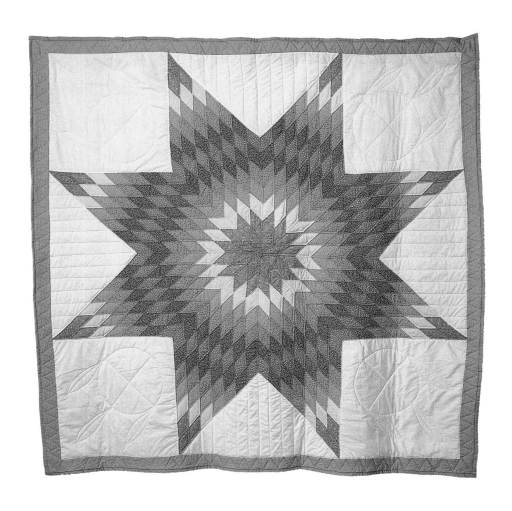

LEDA JOHNSON
Star quilt, 1994
Pieced and quilted cotton/polyester-blend fabrics
80"h. x 80"w.
Sisters of the Great Lakes: The Nokomis Collection
MSU Museum 7594.1; FAD 94.81.1

■

LEDA JOHNSON

Ojibway
Wallaceburg, Ontario

Among native peoples, quiltmaking has become a form of artistic expression that has meaning in the everyday and ceremonial life of the community. Even though the basic form, materials, and techniques of quiltmaking were introduced to native peoples through contact with European missionaries and traders, native quiltmakers have appropriated the art for their own individual and tribal uses.

Leda Johnson, a self-taught quilter, often uses the four- or eight-pointed *Star* pattern, one of the most widely used designs among native quiltmakers. The number four is powerfully symbolic in Native American culture, representing the four directions, the four stages of life, the four races of mankind, and the four sacred plants. Johnson favors the traditional colors of spring and fall. In 1992, one of her intricately stitched quilts was shown on the cover of the Nokomis Learning Center auction catalog.

Passing her skills along to the next generation is important to Johnson, who has taught quiltmaking to her daughter Bonnie. Together, they make quilts to use at home, to sell, and to give as gifts.

Like many of the "Sisters" participants, Johnson is a multitalented artist. She excels in the art of making sweetgrass baskets, which she learned from her sister-in-law. She is particularly skilled in the traditional techniques of identifying, harvesting, and preparing the sweetgrass and birchbark materials used in making the sewn, coil-construction baskets. Johnson sells her quilts and baskets at pow wows and in a shop located in her home.

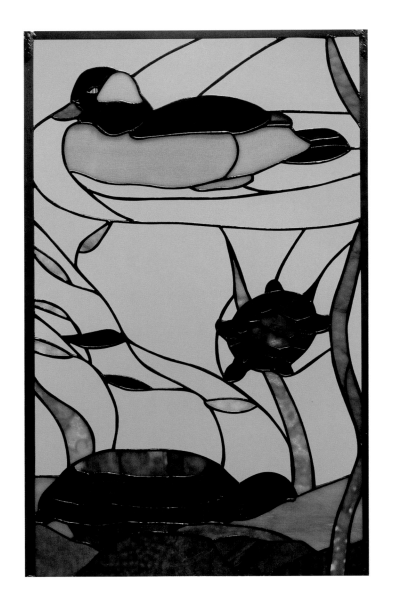

DOLORES LABAN
Wetland Brothers, 1993
Stained glass and lead
27¾"h. x 16¾"w.
Sisters of the Great Lakes: The Nokomis Collection
MSU Museum 7594.13; FAD 94.81.13

■

DOLORES LABAN

Ottawa/Chippewa
Grand Rapids, Michigan

With ancestral ties to Ottawa tribal leader Chief Pontiac, Dolores Gwendolyn Laban is Grand River Ottawa and Saginaw Swan Creek/Black River Chippewa. While growing up, she was exposed to the many traditional arts practiced by family and community members and was influenced by her mother's braided rugs, baskets, quilts, and caning. Laban recalls

that her mother used to "cut patterns from newspapers to make doll clothes and play clothes for us. All these were functional home use articles but still a learning art form for us."

While raising her own children, Laban worked full-time in a factory and tried her hand at oil painting and pottery. It was not until 1983, however, that she added artmaking to her busy life on a regular basis after taking a course in stained glass.

Laban immediately felt that stained glass, although a very nontraditional art within her community's cultural experience, was a medium through which she could express her Native American heritage. Her work reflects traditional and deeply spiritual themes and includes depictions of feathers, traditional dancers, and animals and plants that figure prominently in Native American beliefs.

Her work has been exhibited at pow wows and cultural centers around the country and is represented in many museums and private collections.

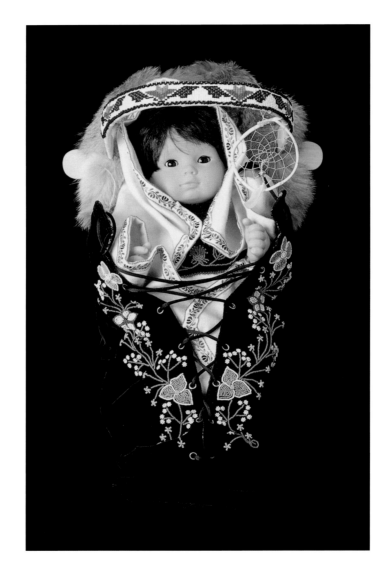

BECKY MUNZ
Infant doll with cradleboard, 1994
Beaded and appliquéd cloth and wood trimmed
with rabbit fur and beads
Doll: 16½"h.
Cradleboard: 18½"h.
Sisters of the Great Lakes: The Nokomis Collection
MSU Museum 7594.19; FAD 94.81.19

■

BECKY MUNZ

Ojibway
Bay Mills, Michigan

Becky Munz was born in Bay Mills, Michigan, where she was introduced at an early age to that community's rich artistic traditions. She and her family have recently returned to the Bay Mills area after living for more than 30 years near Madison, Wisconsin. In Madison, Munz was an active advocate of minority student education and

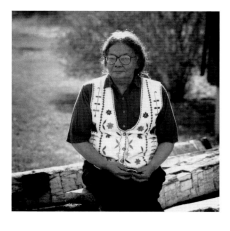

achievement. She regularly conducted workshops on beading, basket weaving, and dreamcatchers for the Madison Metropolitan School District and the Madison Children's Museum.

Within the Woodland Indian culture, dolls were traditionally made of natural materials, including bass wood, birchbark, grasses, pine needles, spruce roots, and willow twigs. Following contact with European cultures, Native Americans made dolls out of animal skins, sometimes stuffing them with moss. These dolls were usually dressed in clothes made of broadcloth or cotton. Sometimes the clothing was decorated with beaded ornamentation, but generally the dolls remained faceless.

When Munz could not find "nice" commercially produced Indian dolls for her daughters, she was inspired to create her own. Known as "Becky's Babies," the dolls feature commercially made bodies clothed entirely in hand-made outfits. The fabrics, designs, and techniques used in creating the leggings, moccasins, shirts, sashes, headdresses, and hand-held fans reflect a combination of the traditional dress styles of many different Native American groups. Although she originally made dolls only for her family, Munz now sells a few numbered and signed dolls that are highly sought after by collectors.

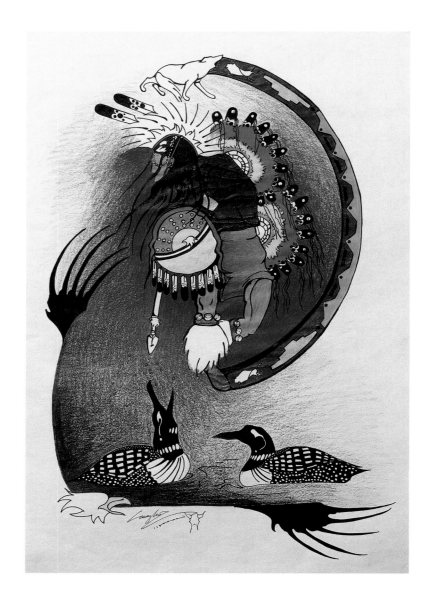

CASEY MUNZ
Water's Meet, 1992
Oil pencil on parchment
18"h. x 12"w.
Sisters of the Great Lakes: The Nokomis Collection
MSU Museum 7594.12; FAD 94.81.12

■

CASEY MUNZ

Western Thunderbird Woman
Ojibway
Bay Mills, Michigan

Born in 1976 in Richland Center, Wisconsin, Casey Munz grew up in a household where both her Ojibway mother and German father valued and supported her exploration of American Indian culture. Munz returns regularly to her mother's home on the Bay Mills Reservation to learn from elders. Though she found support within her home for exploring her heritage within contemporary artistic media, she found little guidance or encouragement in public school art classes. While in high school, she formed an activist group called "Nizo" with several other American Indian students. After graduation, she enrolled in the Institute of American

Indian Arts in Santa Fe, New Mexico. There she studied with guest instructor and well-known photographer Jolene Rickard, among others.

Although her work has been influenced by many people and experiences, Munz wants to use her art to honor those who came before her and to teach others. Her work is rich with Native American cultural symbols, stories, and images. She signs her work with a buffalo skull or an arrow next to her name. Recently, Munz was commissioned to do a pen-and-ink illustration to accompany the words of Chief Seattle. The design she developed features five fingers of a hand, each adorned with unique and intricate symbolic designs.

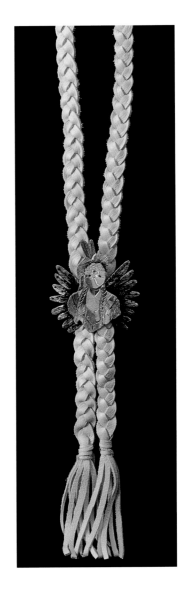

DEBRA ANN PINE
Men's bolo tie ornament, 1994
Sterling silver and braided deerskin
22½" h. x ⅝" w.
Sisters of the Great Lakes: The Nokomis Collection
MSU Museum 7594.2; FAD 94.81.2

∎

DEBRA ANN PINE

She-Shuggia (Blue Huron Crane)
Ojibway
Sault Ste. Marie, Michigan

Debra Ann Pine was born in Sault Ste. Marie, Michigan, and graduated from Sault Ste. Marie High School in 1986. First, second, and third place awards in the drawing category of the Institute of American Indian Arts National High School Art competition led to a scholarship at the institute. After receiving an associate's degree in three-dimensional art

and the institute's prestigious Helen Hardin Memorial Award upon graduation, she returned to Sault Ste. Marie. In November 1993, Pine was selected by the U. S. military to represent the United States in Europe during Native American Month. She toured Germany, Belgium, and Austria with other Native American artists and dancers.

Because Pine comes from a family that actively maintains Ojibway cultural traditions, it is no surprise that her art draws on her Indian heritage. Traditional Woodland Indian themes, floral beadwork patterns, pictograph images, subjects from Ojibway mythology, and her experiences with everyday and ceremonial life form the basis for her designs. Her work relies on the indigenous metals—silver and copper—of her home in the Lake Superior basin. These influences merge with her professional training and awareness of international design, resulting in one-of-a-kind jewelry creations.

Pine continues to be involved in a variety of traditional and modern spheres of activity: she participates as a dancer in regional pow wows and, as a maker of fine jewelry, is represented by six galleries in the Great Lakes area.

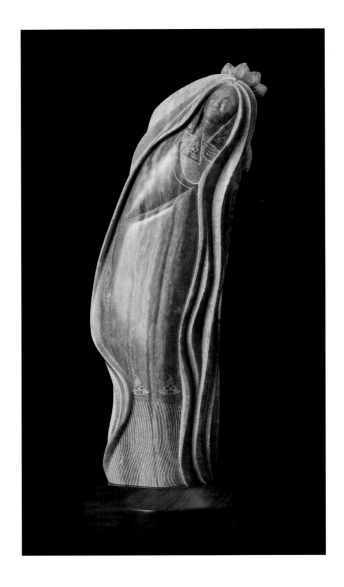

DIANE QUILLEN
Dreamdancer, 1994
Alabaster stone
19⅝"h. (incl. walnut base)
Sisters of the Great Lakes: The Nokomis Collection
MSU Museum 7594.21; FAD 94.81.21

■

DIANE QUILLEN

Menes (Dove)
Saginaw Chippewa of the Swan Creek and Black River Band
Rosebush, Michigan

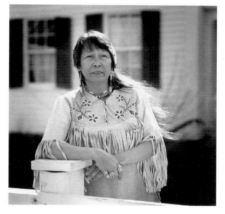

Born in 1942 in Mt. Pleasant, Michigan, Diane Quillen thinks she was born to be an artist. "As long as I can remember," she notes, "I have been able to draw. As I walk through life, always my artistic ability has followed me, placing my belongings in a pretty way, little expressions of my nature." Her grandmother Pelcher, known for her quilting and beading, gave Quillen some of her first lessons in sewing and beadwork. Quillen had her first exhibit when she was in the seventh grade—a showcase in the high school hallway. Over the years, Quillen has been exposed to a variety of artistic expressions within Indian culture and has worked in many materials, including feathers, leather, wood, paint, and clay.

Several years ago she tried sculpting alabaster stone and immediately fell in love with the beauty of the rock. Until then she had never seriously considered an art career. "Nothing had captured my attention so completely," she states. "Since I have been artistically active all my life, it took me a long time to find my real love." Now that she has found this love, it is very difficult for her to part with finished work and she does not sell many pieces. She is currently working with Dennis R. Christy, her cousin and a master sculptor.

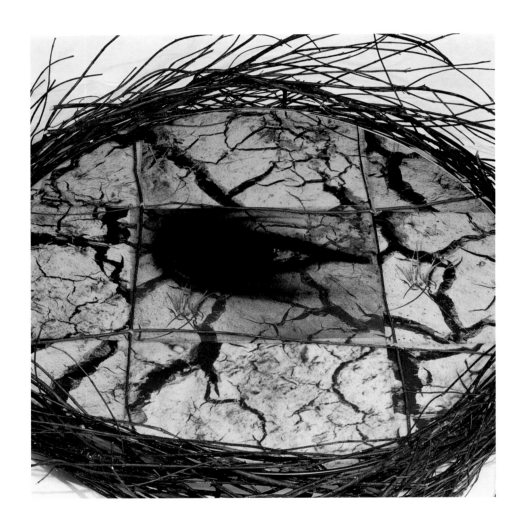

JOLENE RICKARD
Skywoman Looks Back (detail), 1995
Photographic transparency with red whip twigs and acrylic on steel
frame with fluorescent lights
79"d. (with twigs)
Sisters of the Great Lakes: The Nokomis Collection
MSU Museum 7594.24; FAD 94.81.24

■

JOLENE RICKARD

Tuscarora
Sanborn, New York

Jolene Rickard's grandfather once said to her that "the Indian canoe is too swift for white culture. You have to decide which way you are going to go." A member of the Turtle Clan of the Tuscarora nation, Rickard has chosen a path that reflects deep connections with her cultural heritage. She is a highly respected professional photographer whose work has appeared at the Heard Museum (Phoenix, Arizona), Denver Art Museum, Memorial Art Gallery (Rochester, New York), Houston Center for Photography, Johnson Museum (Cornell University, Ithaca, New York), and Gallery of the American Indian Community House (New York, New York).

Her work is illustrated in many publications, notably Lucy Lippard's *Mixed Blessings* (Pantheon Books, 1990) and Alfred L. Bush and Lee Clark Mitchell's *The Photograph and the American Indian* (Princeton University Press, 1994).

Currently completing a doctorate in American Studies at the University of New York at Buffalo, she is a widely sought-after consultant, lecturer, and author of Native American art history. Her lectures and essays span a wide array of issues on historical and contemporary art and include, among others, examinations of Native American iconography, the "trickster" in art, Iroquoian women's beadwork, and the relationship between Native American and African-American art. Rickard has taught seminars and workshops on photography at many art centers, colleges, and universities. While teaching at the Institute of American Indian Arts in Santa Fe, one of her students was fellow "Sisters of the Great Lakes" artist Casey Munz.

Rickard uses her photography as a looking glass to examine ideas of native people and as a conduit of collective thought. Though her work often appears to be very modern, her portraits usually include tiny, red-colored designs that have specific meaning in Tuscarora culture. Rickard slyly and humorously juxtaposes seemingly incongruous visual elements to challenge viewers to reflect on the multiple levels of culture. This use of a visual element meant to tease or "trick" the viewer is an important aspect of American Indian life and the "trickster" character figures in Native American oral and visual traditions.

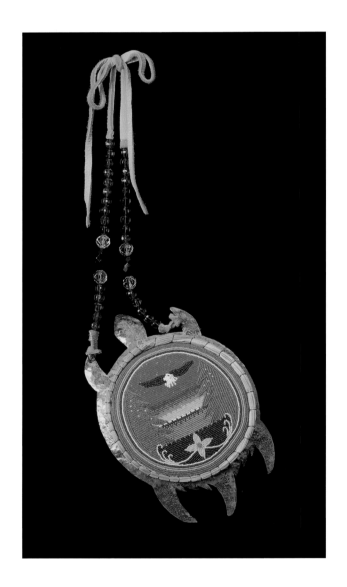

LORRAINE SHANANAQUET
Great Turtle Island, 1994
Beaded copper pendant with sweetgrass and deerskin ties
8¾"h.
Sisters of the Great Lakes: The Nokomis Collection
MSU Museum 7594.3; FAD 94.81.3

■

LORRAINE SHANANAQUET

Wa-sa-bien-no-qua (Lady of the Northern Light)
Ojibwe (Lynx Clan)/Potawatomi
Hopkins, Michigan

Punkin, as Lorraine Shananaquet is known, comes from a family of artists and cultural leaders. George Martin, her father, is a highly accomplished beadworker and carver who often serves as a head dancer and judge in pow wows in the Great Lakes area. Her mother, Sydney Martin, is a respected maker of clothing and dance regalia. Her husband, David Shananaquet, is a well-known painter whose work hangs in numerous museums and galleries in Michigan.

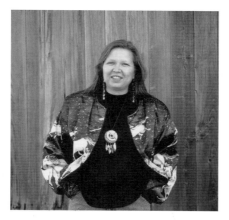

Shananaquet carries on her family's traditions of beading, regalia making, and dancing and is often asked to be the lead dancer in area pow wows. She takes a special interest in beadwork and painstakingly combs shops, garage sales, and flea markets to locate old garments made of the tiny antique beads she prefers to use in her work. Her regalia incorporates traditional materials, symbols, and designs of the Woodland Indians.

Shananaquet is passing on her traditional knowledge to her children, who regularly assist her with beading and dance in regional pow wows. Accompanied at times by other members of her family, she occasionally makes cultural presentations to schools and other organizations.

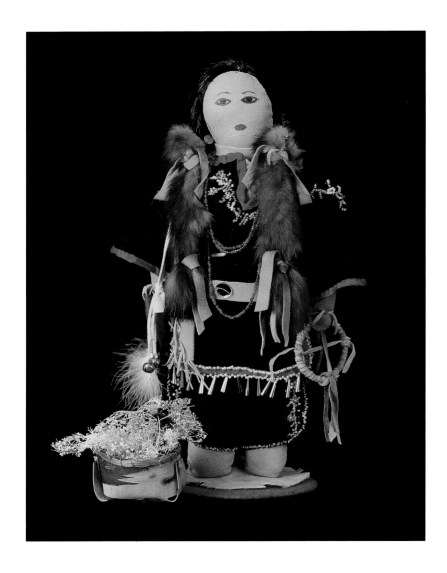

SHARON SKOLNICK
Naomi, 1994
Painted cloth, felt, deerskin, woodbark, dried flowers, horsehair, fur,
plastic beads, and metal jingle bells
14"h.
Sisters of the Great Lakes: The Nokomis Collection
MSU Museum 7594.7; FAD 94.81.7

■

SHARON SKOLNICK

Okee-Chee (Little Blue Bird)
Ft. Sills Apache
Chicago, Illinois

Sharon Skolnick attended the Institute of American Indian Arts in Santa Fe, New Mexico, from 1965 to 1966. She then moved to Chicago, where she raised four children and became an activist in the urban American Indian community. The O Wai Ya Wa Indian School, the American Indian Center, Indian Council Fire, and the American Indian Health Service are a few of the organizations for which she has served advocacy roles. Her leadership extends well beyond the Indian community, however. She currently serves as secretary of the Andersonville Chamber of Commerce, chairperson of the chamber's public safety committee, and liaison with Chicago's Twentieth Police District. Yet for all these impressive activities, she is known primarily as a painter and active promoter of Indian art.

Skolnick is the owner and manager of Okee-Chee's Wild Horse Gallery, a showcase of American Indian art located in Chicago's Andersonville neighborhood. She is also a founding member of the Chicago Indian Artist Guild. She identifies and encourages local Indian talent in a variety of ways, and has helped organize more than 100 local exhibits of Native American art. She also serves as a judge at fairs and pow wows.

In her paintings, graphic arts, and doll-making, Skolnick draws on traditional symbolism and her own experiences. Her dolls are dressed in traditional attire made of fur, horsehair, deer hide, porcupine quills, feathers, leather, and cloth trimmed with beaded and appliquéd designs. Sometimes they carry hand-held fans, medicine wheels, and baskets. Although her tribal affiliation is Ft. Sills Apache, her work strongly reflects the designs and traditions of the Great Lakes region where she has spent her entire life.

Skolnick has initiated many innovative projects that bring the Native American cultural heritage to a wider audience. Among these are the Native American Christmas tree that is part of the Museum of Science and Industry's "Christmas Around the World" exhibit, and "Portraits: Indian Chicago," a series of large-scale oil paintings that were the subject of a 30-minute television documentary produced by the Chicago NBC affiliate.

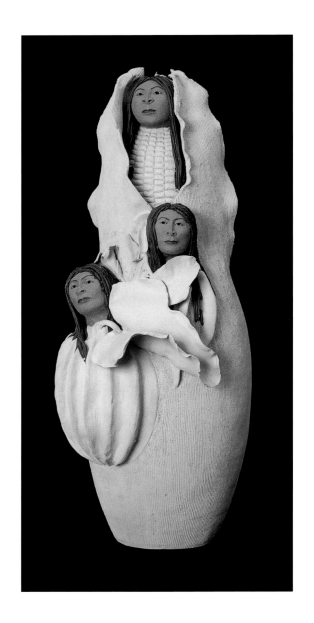

TAMMY TARBELL-BOEHNING
Three Sisters, 1994
Clay
23½"h.
Sisters of the Great Lakes: The Nokomis Collection
MSU Museum 7594.15; FAD 94.81.15

■

TAMMY TARBELL-BOEHNING

Mohawk
Onondaga, New York

Tammy Tarbell-Boehning was raised near the Onondaga Indian Reservation in upper New York state, and her Iroquois heritage remains very important to all aspects of her life. She began expressing herself in the visual arts at an early age and later studied graphic art at Onondaga Community College and at Syracuse University, where she received a bachelor of fine arts degree. As a college student, she developed a love for clay and has since specialized in ceramics.

To give expression to her own heritage, she incorporates the shapes and designs of old-style Iroquois pottery and uses traditional materials such as feathers, hide, and glass beads. Her figurative pottery combines old and new techniques and materials in the representation of American Indian women. In these clay works she attempts to capture the essence of the Native American woman's spiritual way of life. Tarbell-Boehning is a self-employed potter and sculptor whose work can be seen in Native American art shows and museum collections across the country. With her business partner/husband, Tarbell-Boehning enjoys traveling to museums, pow wows, and art markets. In 1987 she served as artist-in-residence at the Metropolitan School for the Arts in Syracuse, New York.

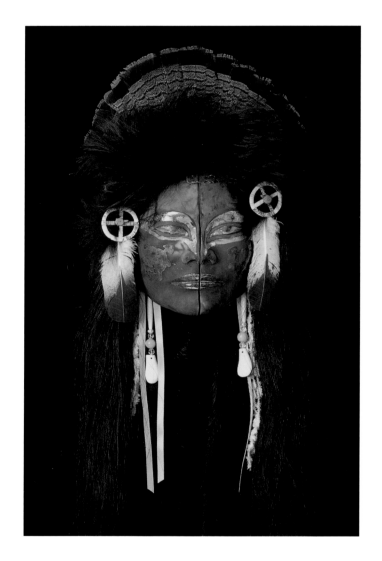

SALLY THIELEN
Water Woman, 1994
Mask with interactive video camera
Rakú-fired porcelain, horsehair, mink, feathers, glass,
plastic, turquoise beads, and cloth
47"h. (incl. headdress and hairpieces)
Sisters of the Great Lakes: The Nokomis Collection
MSU Museum 7594.23; FAD 94.81.23

■

SALLY THIELEN

Mashue (South Eagle Woman)
Chippewa
Davison, Michigan

Although Sally Thielen was raised in a family that impressed upon her the richness of her cultural heritage, it wasn't until becoming disenchanted with her career in nursing that she began to seek a way of visually expressing that heritage. A community education class in pottery was followed by five years of study at the Flint Institute of Arts, where she also received training in weaving and making handmade paper.

Sally Thielen is recognized as an accomplished artist in many media, but is perhaps best known for her rakú porcelain masks. She uses only Native Americans as models. When the masks are finished, she preserves her models' identities by referring to them only by their first names.

In addition to creating art, Thielen regularly teaches in adult education and private schools. Family involvement in her art is important to her, and each family member contributes in an important way: her husband provides technical and marketing assistance, her children serve as valuable in-house critics, and her grandchildren are eager students of the Chippewa traditions that she shares with them. In order to create beaded bags and ornaments faithful to these traditions, Thielen spends hours researching historical and contemporary patterns and designs.

Thielen's work has been shown in galleries and museums all over the world, including Russia, Canada, France, and numerous locations in the United States. She was recently honored to be asked to create a beaded ornament for the White House Christmas tree.

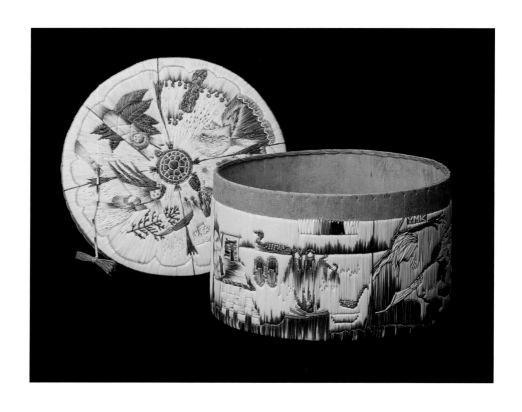

YVONNE M. WALKER-KESHICK
To Our Sisters, 1994
Birchbark box and lid with porcupine quill embroidery and sweetgrass trim
5¼"h., 8⅛"d.
Sisters of the Great Lakes: The Nokomis Collection
MSU Museum 7594.20; FAD 94.81.20

YVONNE M. WALKER-KESHICK

Falling Leaf
Odawa/Ojibwa
Northern Emmet County, Michigan

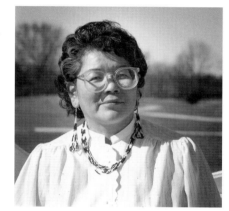

Because Yvonne Walker-Keshick was born in the autumn of 1946, her tribal name is Falling Leaf. One of the five children of Levi and Josephine Walker, she is the descendant of a long line of excellent quill-workers. Her grandmother, Mary Anne Kiogima, was reputedly one of the finest quillworkers of the early twentieth century. Quillworkers embroider designs on birchbark containers with natural and dyed porcupine quills. Walker-Keshick began making porcupine quill boxes in 1968 with her aunt and teacher, Susan Shagonaby.

Historically, porcupine quill designs were passed from one generation to the next. Families sometimes owned the rights to certain designs. The quillworkers in Walker-Keshick's family are known for creating quilled designs of wildlife with exquisite realism. Their animals bristle with life; their floral designs reflect the intricate delicacy of the plants themselves. Walker-Keshick learned many of Shagonaby's designs and also draws on nature for her own motifs. She has designed boxes with fish at the start of trout season and lightning bolts after a severe rainstorm.

Walker-Keshick does not usually dye the porcupine quills she uses because she does not like the way the color fades after a few years.

Walker-Keshick became a full-time quill-worker and teacher in 1980. Since then, she has generously shared her skills with her family and community. She has written a manuscript on quillwork that provides technical instruction and describes the cultural meanings related to this tradition. She is adamant about the responsibility of the old to teach the young: "I believe it is truly our responsibility to teach others all of the best things of our culture. Teaching! This is what our elders did for us and it is what we as elders have to do for our young people."

Walker-Keshick is one of the finest quillworkers in North America and a dominant force in preserving the cultural heritage of the Little Traverse Bay Band of Odawa. In 1992 she received a Michigan Heritage Award in recognition of her commitment to Odawa heritage, her willingness to train others, and her many artistic accomplishments.

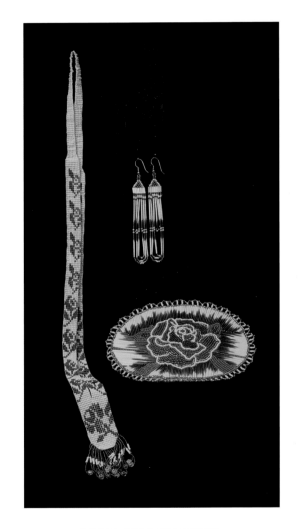

LINDA (TOPASH) YAZEL
Barrette, necklace, and earrings, 1994
Beads, porcupine quills, and leather
Barrette: 6¼"h. x 4½"w.
Necklace: 20¼"h.
Earrings: 4⅝"h.
Sisters of the Great Lakes: The Nokomis Collection
MSU Museum 7594.6; FAD 94.81.6
MSU Museum 7594.5; FAD 94.81.5
MSU Museum 7594.4; FAD 94.81.4